ART REVOLUTIONS
IMPRESSIONISM

Linda Bolton

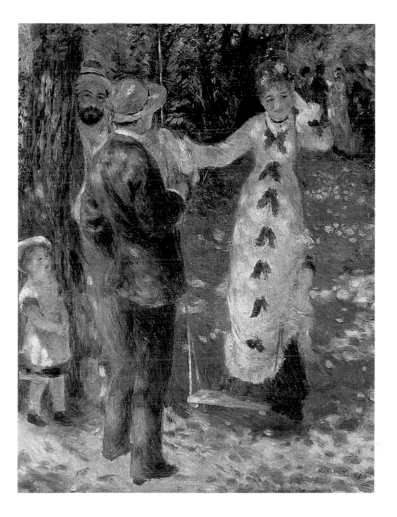

Belitha Press

First published in Great Britain in 2000 by

Belitha Press Limited
A member of Chrysalis Books plc
64 Brewery Road, London N7 9NT

Paperback edition first published in 2003

Editor Susie Brooks
Designer Helen James
Picture Researcher Diana Morris
Educational Consultant Hester Collicutt

ISBN 1 84138 106 3 (hb)
ISBN 1 84138 774 6 (pb)

British Library Cataloguing in Publication Data
for this book is available from the British Library.

Printed in China

Picture Credits:

Front cover: Claude Monet, Rue Montorgeuil, 1878. Musée d'Orsay, Paris. Photo Bulloz/Bridgeman Art Library. 1: Pierre Auguste Renoir, The Swing, 1876. Musée d'Orsay, Paris. Photo Giraudon/Bridgeman Art Library. 4: Claude Monet, Impression Sunrise, 1872. Musée Marmottan, Paris. Photo Peter Willi/Bridgeman Art Library. 5: JMW Turner, Rain, Steam and Speed, 1844. National Gallery, London. Photo Erich Lessing/AKG London. 6: Pierre Auguste Renoir, La Loge, 1874. Courtauld Institute Galleries, London. Photo Bridgeman Art Library. 7t: Edouard Manet, The Rue Mosnier with Pavers, 1878. Private Collection. Photo Bridgeman Art Library. 7b: Claude Monet, Gare St-Lazare, 1877. Musée d'Orsay, Paris. Photo Bulloz/Bridgeman Art Library. 8: Claude Monet, Wild Poppies, 1873. Musée d'Orsay, Paris. Photo Peter Willi/Bridgeman Art Library. 9t: Claude Monet, La Pie, 1868-9. Musée d'Orsay, Paris. Photo Peter Willi/Bridgeman Art Library. 9b: Claude Monet, Rue Montorgeuil, 1878. Musée d'Orsay, Paris. Photo Bulloz/Bridgeman Art Library. 10: Pierre Auguste Renoir, Bal au Moulin de la Galette, 1876. Musée d'Orsay, Paris. Photo Giraudon/Bridgeman Art Library. 11t: Pierre Auguste Renoir, Boating Lunch Party, 1881. Phillips Collection, Washington. Photo Edward Owen/Bridgeman Art Library. 11b: Pierre Auguste Renoir, The Swing, 1876. Musée d'Orsay, Paris. Photo Giraudon/Bridgeman Art Library. 12: Camille Pissarro, Entrance to Village of Voisins, 1872. Musée d'Orsay, Paris. Photo Giraudon/Bridgeman Art Library. 13t: Pissarro, Boulevard Montmartre at Night, 1897. National Gallery, London. Photo Bridgeman Art Library. 13b: Camille Pissarro, Coach at Louveciennes, 1870. Musée d'Orsay, Paris. Photo Bridgeman Art Library. 14: Alfred Sisley, Canal at St Martin, Paris, 1870. Musée d'Orsay, Paris. Photo Erich Lessing/AKG London. 15t: Alfred Sisley, Square at Argenteuil, 1872. Musée d'Orsay, Paris. Photo Giraudon/Bridgeman Art Library. 15b: Alfred Sisley, Barge during Floods, Port Marly, 1876. Musée d'Orsay, Paris. Photo Erich Lessing/AKG London. 16: Edouard Manet, The Balcony, 1869. Musée d'Orsay, Paris. Photo Erich Lessing/AKG London. 17t: Edouard Manet, Bar at the Folies Bergère, 1882. Courtauld Insititute Galleries, London. Photo Bridgeman Art Library. 17b: Edouard Manet, Argenteuil, Monet's Studio Boat, 1874. Neue Pinakothek, Munich. Photo Bridgeman Art Library. 18: Berthe Morisot, The Cradle, 1872. Musée d'Orsay, Paris. Photo Peter Willi/ Bridgeman Art Library. 19: Berthe Morisot, In the Dining Room, 1886. National Gallery of Art, Washington. Photo Bridgeman Art Library. 20: Edgar Degas, At the Café des Ambassadeurs, 1875. Musée des Beaux Arts, Lyons. Photo Giraudon/Bridgeman Art Library. 21t: Edgar Degas, Dancer Taking a Bow, 1878. Musée d'Orsay, Paris. Photo Erich Lessing/AKG London. 21b: Edgar Degas, Miss Lala, 1878. National Gallery, London. Photo Bridgeman Art Library. 22: Mary Cassatt, In the Box, 1879. National Gallery of Art, Washington. Photo Bridgeman Art Library. 23: Mary Cassatt, The Cup of Tea, 1879. The Metropolitan Museum of Art, from the Collection of James Stillman. Gift of Dr Ernest G. Stillman, 1922. Photograph © 1998 The Metropolitan Museum of Art. 24: Gustave Caillebotte, Paris in the Rain, 1877. Art Institute of Chicago. Photo Erich Lessing/AKG London. 25t: Gustave Caillebotte, The Parquet Planers, 1875. Musée d'Orsay, Paris. Photo Lauros-Giraudon/Bridgeman Art Library. 25b: Gustave Caillebotte, Pont de l'Europe, 1876. Petit Palais, Geneva. Photo Bridgeman Art Library. 26: Vincent Van Gogh, Moulin de la Galette, Montmartre, 1886. Glasgow Art Gallery & Museum. Photo Bridgeman Art Library. 27: Vincent Van Gogh, Restaurant de la Sirene, Joinville, 1878. Musée d'Orsay, Paris. Photo Peter Willi/Bridgeman Art Library. 28t: James MacNeil Whistler, Nocturne in Blue and Gold, c 1865. Tate Gallery, London. Photo Erich Lessing/AKG London. 28b: Paul Gaugin, Rue Carcel Covered in Snow, 1883. Ny Carlsberg Glyptothek, Copenhagen. Photo Erich Lessing/AKG London. 29t: Paul Cézanne, Tall Trees at Jas de Bouffan, c. 1883. Courtauld Institute Galleries, London. Photo: Bridgeman Art Library. 29b: Georges Seurat, Sunday Afternoon on the Isle of the Grande Jatte, 1884-6. Art Institute of Chicago. Photo Bridgeman Art Library.

CONTENTS

Useful words are explained on page 30.
A timeline appears on page 31.

IMPRESSIONIST SPLASH!

Can you exhibit a painting that looks unfinished? Would you paint road menders working in the street? Can you see pinks, blues and yellows in a patch of white snow? The Impressionists did! Their bright, lively brushwork startled the critics. But what inspired this eye-catching art revolution?

Impressionist paintings may be popular today, but when they were first seen, they shocked the art world. The name Impressionism was actually given by an art expert as an insult!

Unlike the realistic art of the past, Impressionist paintings looked unfinished. When critics first saw them exhibited in 1874, they were outraged! This art broke from tradition – it was modern.

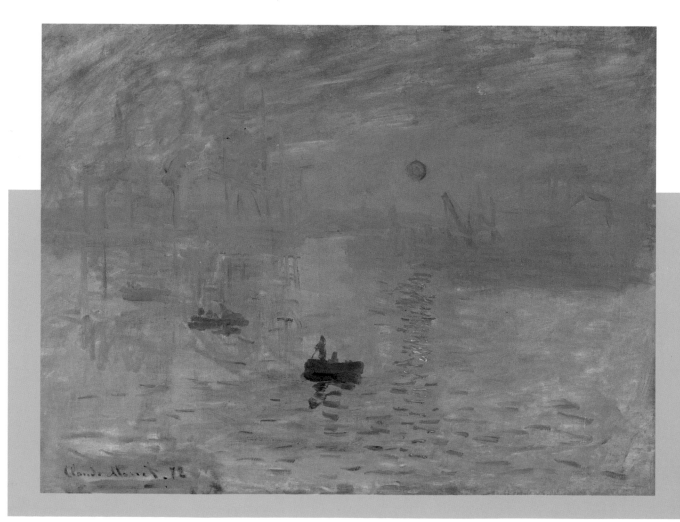

The Impressionists looked at the world in a new way. They were excited by the invention of photography, which helped them to see how movement, light and distance can blur things and break up solid forms. The Impressionists wanted to recreate these effects on canvas. Instead of painting clean outlines, they applied colour in big, broken brush-strokes. This helped them to create an impression of motion and change.

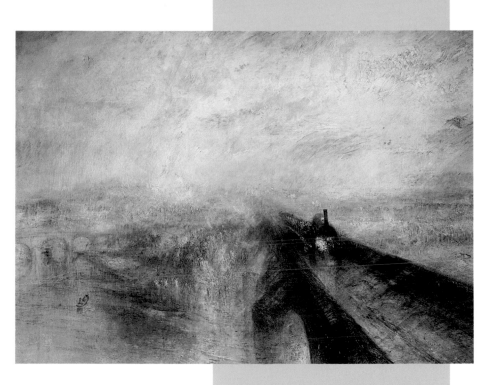

The Impressionists didn't like the traditional way of painting inside a studio. They wanted to work closer to nature, out in the open air. The invention of oil paint in tubes helped them to do this. Before, artists had to mix pigment with oil to make paints – this wasn't easy to do outside. But the Impressionists had a whole new range of bright colours that they could use wherever they liked. Out in the open they could paint what they saw and felt, from hot, shimmering sunlight to breezes rustling trees.

JMW TURNER
Rain, Steam and Speed

1844, oil paint on canvas

The Impressionists weren't the first to try to paint the changing effects of nature. A British artist called Joseph Mallord William Turner had been working on images of wind, rain and sunshine 30 years earlier. Monet and his friend Pissarro saw paintings such as this one when they first visited London in 1870. They admired the way Turner had created the feeling of a fast-moving steam train in a storm. Perhaps it was this that later inspired Monet to paint a series of steam trains himself.

CLAUDE MONET
Impression, Sunrise

1872, oil paint on canvas

When Monet chose the title for this painting, he might not have expected it to name a new art movement! But when it appeared in the 1874 Paris exhibition, art critic Louis Leroy picked up on the word impression. He called Monet and his fellow artists the Impressionists, accusing their work of being sketchy and incomplete. Within a year this label was being used throughout the art world.

The Impressionists first made a splash in the city of Paris. This was a fast-changing place in the last few decades of the nineteenth century. Vast tree-lined boulevards, alive with cafes and theatres, replaced quiet old medieval streets. People dressed in fashionable clothes and enjoyed being out and about. Groups of friends met up to drink, dance or see a show.

The Impressionists found the colour and energy of this growing metropolis exciting. They began making paintings that reflected the lively hustle and bustle of modern life. Rejecting traditional classical subjects, Monet and his friends wanted to paint real people in real places. They used the same sketchy brushwork to show figures in a crowd as they did to paint grass in a meadow.

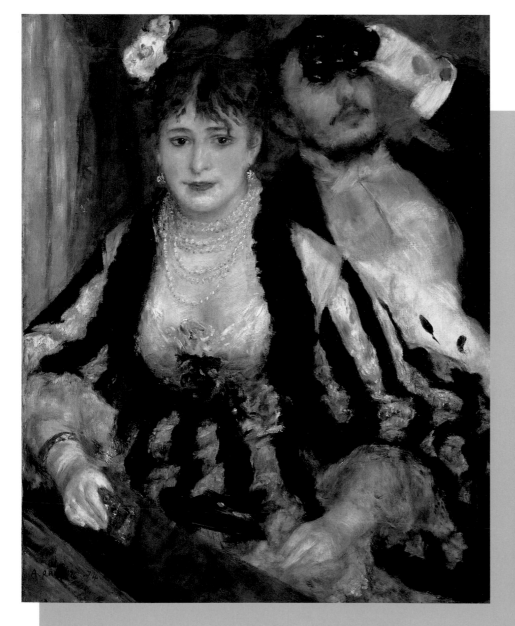

PIERRE AUGUSTE RENOIR
La Loge

1874, oil paint on canvas

This painting shows us a couple in their box at the theatre. They are looking around, probably to see who else is in the audience. The man holds his opera glasses up to his eyes, peering at people in the seats above. The woman is staring out at us. She seems to know she's being watched. People often went to the theatre to see and be seen. This pair are dressed in the rich, glamorous clothes that were fashionable in Impressionist times.

EDOUARD MANET

The Rue Mosnier with Pavers

1878, oil paint on canvas

This is a scene that Manet saw from his studio window. He wanted to record a slice of everyday life, of workers in the street and people passing by. The bright colours are typical of Impressionism. We feel we are looking into warm sunlight.

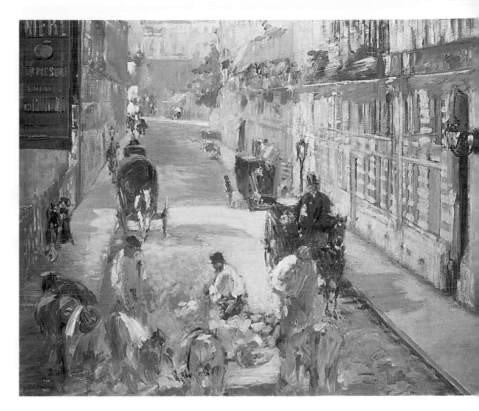

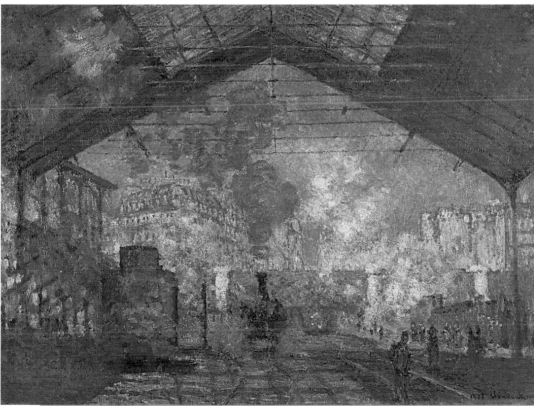

CLAUDE MONET

The Gare Saint-Lazare

1877, oil paint on canvas

Railway stations were symbols of the modern age of steam. Monet chose Paris' Gare Saint-Lazare as the subject for a whole series of paintings. The station master was so flattered that he ordered a train driver to release a puff of engine steam, especially for Monet to paint. Monet liked the way the steam blurred the edges of objects around it. Here he recreates the damp, smoky air of the platform.

CLAUDE MONET 1840–1926

'The father of Impressionism.'

Monet was one of the leading Impressionists. He grew up in Normandy, where he was encouraged to paint outside by the artist Eugène Boudin. When Monet moved to Paris to study art, he persuaded others to work in the open air.

Monet moved back to Normandy later in his life. Wherever he lived, he painted the world around him, often recording the same scene in different lights and colours. As he grew old, his favourite subject became his water garden at Giverny.

Wild Poppies

1873, oil paint on canvas

As a young artist, Monet didn't have much money. Paris was an expensive city, so he moved to Argenteuil, on the outskirts, to avoid high rents and find new subjects to paint. Fellow Impressionists Renoir, Sisley, Pissarro and Manet often joined him there. Here Monet has painted his wife Camille and their small son Jean, walking in a field of poppies. He wanted to create the effect of really being there. The colours are warm and bright – we can almost feel the heat of the sun shining through the drifting clouds and hear the gentle breeze whispering in the long grass.

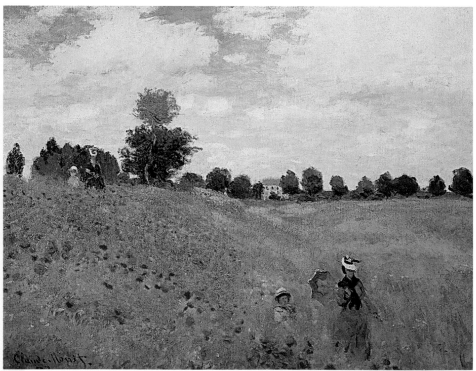

COLOUR PLAY

Colours that are opposite each other on this wheel are called complementaries. The Impressionists found that by mixing or juxtaposing complementary colours, they could create different shades and effects. Why not try your own experiments based on this idea?

The Magpie
1869, oil paint
on canvas

Here Monet makes us feel
the crisp, cold air of a bright
winter morning. You can
almost imagine the icicles
forming on his beard as he
painted this freezing scene!
Monet has made a dazzling
effect by carefully choosing
his colours. His shadows
are not made up of blacks
and greys, but of blues and
mauves. These contrast
with tints of yellow and
pink in the brilliant white patches of sunlit snow.
Seen close up, Monet's canvas is a mass of thick,
multicoloured paintwork. Like many Impressionist
works, it is best viewed from a distance when the
brushstrokes merge and the picture becomes clear.

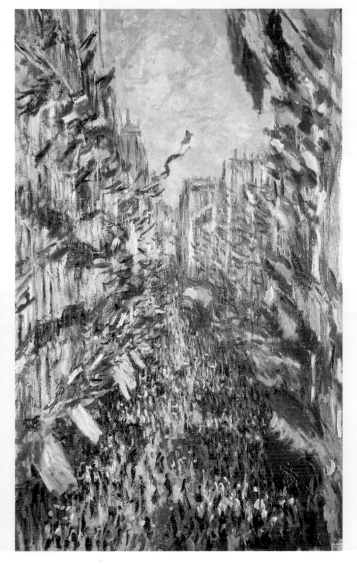

Rue Montorgeuil, Paris
1878, oil paint on canvas

Monet painted this busy Parisian scene on a
national holiday in July. The sketchy strokes of
red, white and blue paint represent thousands of
flapping French flags. The blurred forms swarming
below them are people. Monet has deliberately
avoided solid outlines and fiddly detail. His lively
impasto brushwork gives the effect of movement –
of flags waving in the breeze and crowds bustling
in the street. The bright colours reflect the noise
and excitement of this sunny summer festival.

PIERRE AUGUSTE RENOIR 1841–1919

'The artist with the rainbow palette.'

Pierre Auguste Renoir, son of a tailor and one of five children, enjoyed a happy working-class childhood in Paris. He began his artistic career as a porcelain decorator, making pictures on cups and plates. Afterwards he trained as a painter, sharing a studio with his friend Monet.

Renoir loved to paint people enjoying themselves – groups of friends dining and dancing in bright surroundings, or couples chatting in shady parks. He liked to paint sunlight shining through leaves and falling on people's clothes. His figures all seem to be celebrating – his work is full of life.

Ball at the Moulin de la Galette 1876, oil paint on canvas

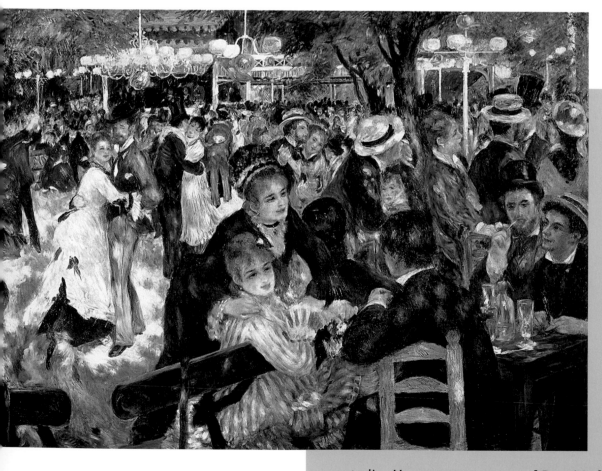

The Moulin de la Galette was an old mill which had been turned into a dance hall. In summertime, dances were held in the courtyard outside. Renoir often went there to paint. This canvas is so large that it's unlikely he painted it on the spot. He probably made sketches there and then worked from them back in his studio. Here we see a group of Renoir's friends, chatting and dancing with local girls. The atmosphere is relaxed and cheerful.

Boating Party Luncheon

1881, oil paint on canvas

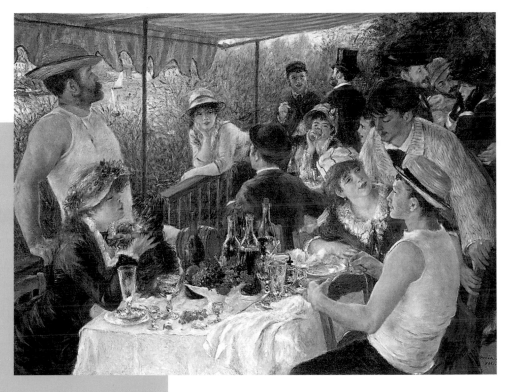

Renoir painted this merry midday scene at Bougival, a picturesque spot on the River Seine. Many Parisians held boating parties there in the summer. This group are finishing off a good lunch, chatting around tables full of bottles, glasses and fruit. Renoir has painted the figures in relaxed positions – they don't look as if they are posing. The glowing light makes us feel warm, as if we're enjoying the sunshine too.

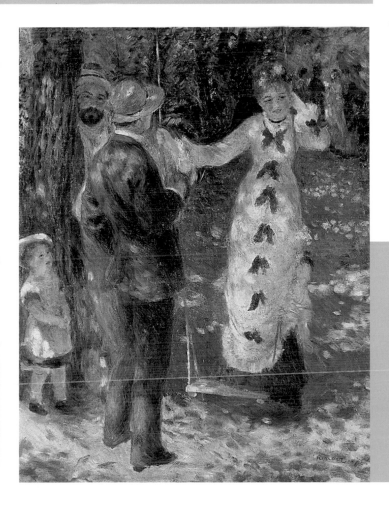

WHITE LIGHT

Renoir applied blobs of colour among patches of white to create different light effects. Paint a red square with a white border around it. Notice how the white glows with green (red's complementary). Try this with the other primary colours.

The Swing

1876, oil paint on canvas

The dappled effect in this painting is typical of Renoir's outdoor scenes. We feel the sun is shining between leaves above, patterning the figures with spots of light and shadow. Touches of colour on the ground create the same effect. The little girl on the left stands partly in the sunlight, watching the adults chatting in the shade. Her form and features are simplified, as if she's out of focus.

CAMILLE PISSARRO 1830–1903

'It is good to draw everything...

Camille Pissarro was born in the Virgin Isles but was sent to school in Paris, where he became interested in art. Later he trained there as a painter, befriending the other Impressionists although he was several years older than them.

Pissarro was the only artist to exhibit in every one of the eight Impressionist shows. He was also a great teacher, working with many younger artists from Cassatt to Cézanne. His main interest was painting the beautiful French countryside.

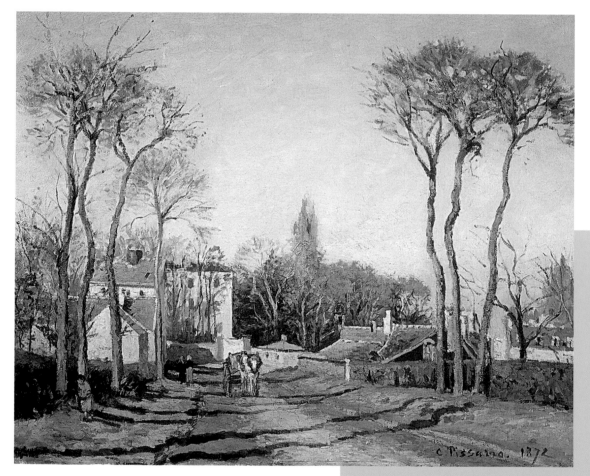

Entrance to Village of Voisins, Yvelines

1872, oil paint on canvas

Pissarro makes us feel that he painted this picture on the spot, putting up his easel at the side of the road to paint what he saw. It's the approach to the village of Voisins, a place he knew well. The air feels fresh and clear. Tall, spindly trees cast long shadows across the dusty track and green grass verge. The atmosphere is peaceful and calm. Looking at this painting, we feel we are alone on a spring morning, listening to singing birds and the distant clip-clop of a horse's hoofs.

Boulevard Montmartre at Night 1897, oil paint on canvas

Pissarro painted this night-time scene from an apartment overlooking the Boulevard Montmartre. Looking down on this rainy Paris street, we see the bright reflections of artificial lights shining from lampposts, buildings and horse-drawn carriages. The road narrows as it approaches the horizon. Pissarro's brushstrokes follow the diagonal skyline, emphasizing the sweep into the distance. He sketches in the people using dashes of paint, creating a smudgy effect like a blurred photograph. This gives us the impression that the figures are moving. The scene looks stormy, wet and alive.

CHANGE OF SCENE

Pissarro was interested in the effects of light at different times of day and in different weathers. Try sketching or taking a photo of the same scene early in the morning, at midday and in the evening. Notice how the length of the shadows changes. Is it different on a cloudy day?

Coach at Louveciennes

1870, oil paint on canvas

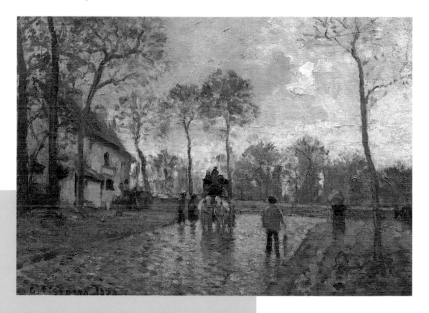

This is the town of Louveciennes, a few miles south of Paris. Pissarro moved here to live more cheaply but still be within easy reach of the city. Monet and Renoir lived nearby, and they would often go to Paris to meet. They probably travelled in a horse-drawn coach such as this one, pausing here on a rainy street. Pissarro's broken brushwork creates the impression of evening light glistening on wet cobbles. The dazzling pinks and whites make us feel the glare of sunshine through the clouds. The atmosphere is warm, damp and calm.

ALFRED SISLEY 1839–1899

'The English Impressionist.'

Alfred Sisley was born in Paris to English parents. At the age of 18 he was sent to London for a business career, but, eager to be an artist, he soon returned to France. The Sisley family lost their money after the Franco-Prussian War. Alfred tried to sell his art to make a living.

Sisley was the most true to the Impressionist title and continued to paint in this style until he died. But he was the least-known artist of the group, and unlike Monet or Renoir he never made much money. Sisley's paintings are everyday views of quiet French villages and simple riverside scenery.

Canal at St Martin, Paris

1872, oil paint on canvas

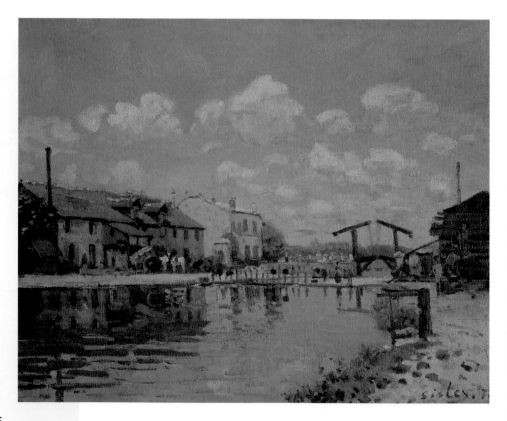

This quiet canal was one of the spots in Paris that Sisley liked to paint. Here we feel we're looking at the water from a bridge, comfortably distant from the action on the far bank. The overwhelming effect is of calm sky and water – two elements which Sisley loved to paint. He tried to create the impression of gently drifting clouds above rippling water. Light from the blue sky glints on the river's surface, creating reflections. The artist varies his brushstrokes to give the effect of movement. There's also a strong sense of space, which makes us feel the fresh air of this sunny day.

WATER WATCH
Broken brushstrokes are an effective way of painting reflections on water. Try making your own waterside scene, looking carefully at changing light and colour.

Rue de la Chausée, Argenteuil 1872, oil on canvas

Sisley often painted at Argenteuil, either on his own or with his Impressionist friends. This is a picture of the town square, with its buildings bathed in the golden sunlight of a summer evening. It's a peaceful scene in which we enjoy the impression of being in a wide open space, dotted with people quietly going about their business. Sisley probably set up his easel in the square to make this painting. We feel we are standing in the shade, looking across at a sunlit street which disappears silently into the distance.

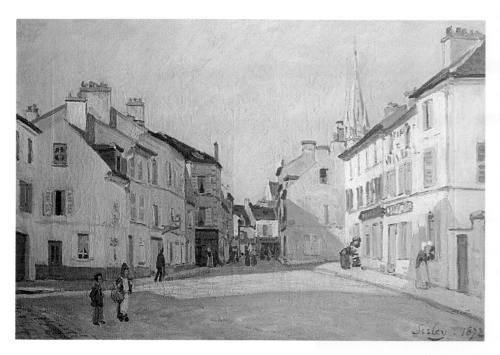

Barge during Floods, Port Marly

1876, oil paint on canvas

Sisley was known as the poet of the riverbanks. He loved to paint water in every season and weather condition. In 1876 the river banks burst at Port Marly where he was living. The water rose right up to the doorway of the local inn. Here Sisley has painted two men on a boat, rowing in the flood waters. There is a feeling of calm after a storm, of clear air after pouring rain. We can see the light wind-blown clouds, blue sky and lone building reflected in the gently rippling water. Cool, fresh colours are laid down in broad strokes.

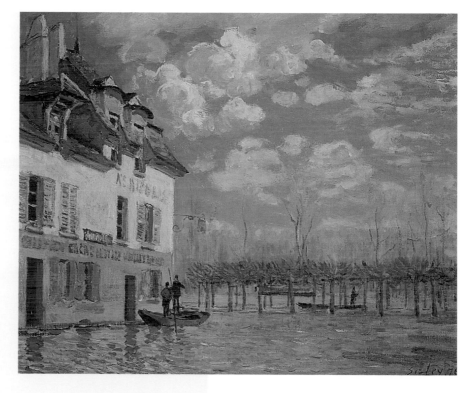

EDOUARD MANET 1832–1883

'Leader of the gang.'

Edouard Manet did not show his work in any of the Impressionist exhibitions, but he did play an important part in the movement. He was leader of *la bande à Manet,* or Manet's gang – a group who met regularly in cafes to talk about painting.

Manet thought it very important to paint modern things, from bars and cafes to railway stations. The younger artists were interested in what he had to say, as well as the paintings he made. Manet paved the way for modern art.

The Balcony

1869, oil paint on canvas

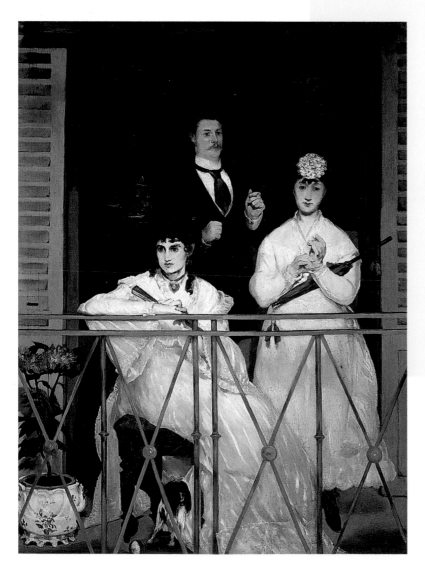

Here we see a group of Manet's friends, posing on the balcony of a Paris apartment. The figure seated on the left is Berthe Morisot. She was Manet's pupil and model, and later became a famous Impressionist herself. Manet was very fond of Morisot. He seems to have taken more care to paint her than the standing woman, violinist Fanny Claus, and the man, landscape artist Antoine Guillemet. The figures don't seem to act as a group. They all gaze out in different directions. What are they looking at? We feel as if we are glancing across at them from the balcony of a building opposite. Do they know they're being watched?

MAKE IT MODERN
Modern life was Manet's theme. Try painting a group of your own friends working, chatting or playing in a modern setting.

Bar at the Folies-Bergère 1882, oil paint on canvas

The people reflected in the background of this painting went to the Folies-Bergère to drink, chat and be seen. Few of them seem to notice the trapeze artist, whose legs are dangling at the top left of the picture. The barmaid probably saw this spectacle every day. What is she thinking? Many people criticized the strange angle at which Manet painted the reflection of the barmaid and her male customer. It's as if the artist is tricking our eyes to make us look harder.

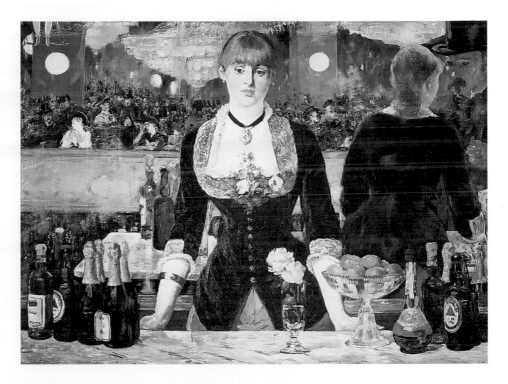

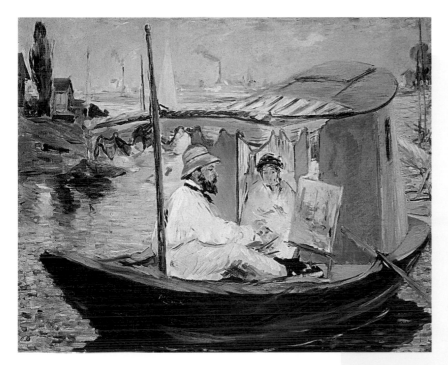

Manet's friend Monet so loved painting water that he converted a boat into a studio! Another friend and painter, Gustave Caillebotte, designed it for him. It had a cabin in which to store equipment, and a striped canopy to keep off the rain or sunshine. Here Manet has painted Monet working on his boat at Argenteuil. His wife Camille joins him. In the background are smoky factory chimneys, symbols of the modern city. Is Monet painting them too? Manet creates the effect of light reflected on water by laying down daubs of bright paint among patches of deeper colour. His sketchy brushwork makes a breezy scene.

Monet in his Studio Boat, Argenteuil

1874, oil paint on canvas

BERTHE MORISOT

1841–1895

'The one real Impressionist.'

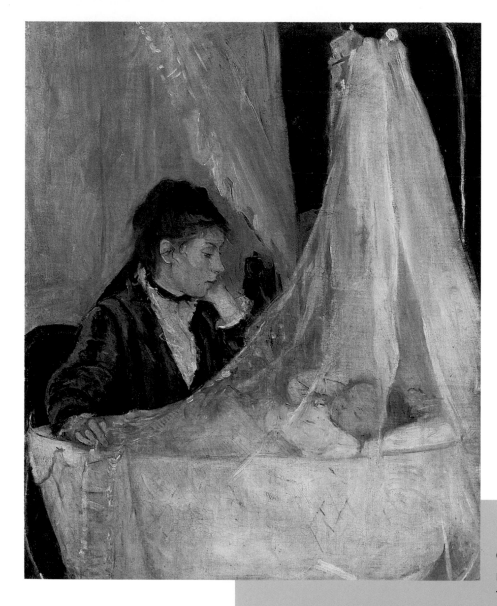

The Cradle

1872, oil paint on canvas

Berthe Morisot came from a wealthy family. She and her sister trained as painters in Paris, where Berthe met Manet and his friends. She often modelled for Manet, and later married his brother.

Morisot exhibited in all but one of the eight Impressionist shows. She and her husband had plenty of money, so they were able help fund the 1886 exhibition. Morisot liked to paint everyday family scenes in simple yet elegant interiors. She applied her paint freely and in all directions. Her brushstrokes are very light and delicate, like feathers.

Here we see a simple scene of a loving mother tenderly rocking her baby's cradle. The woman is Berthe's sister, Edma. Her dark hair and dress are framed by the white curtain that hangs in the window. This white is muted with soft blues and pale orange tones, setting it back behind the seated figure. The white of the cradle's drape is much brighter. Morisot uses dazzling pinks and golds to give the impression of light shimmering on delicate fabric. We feel this is much closer to us, right in front of our eyes. Morisot's broad brushstrokes give the effect of different textures.

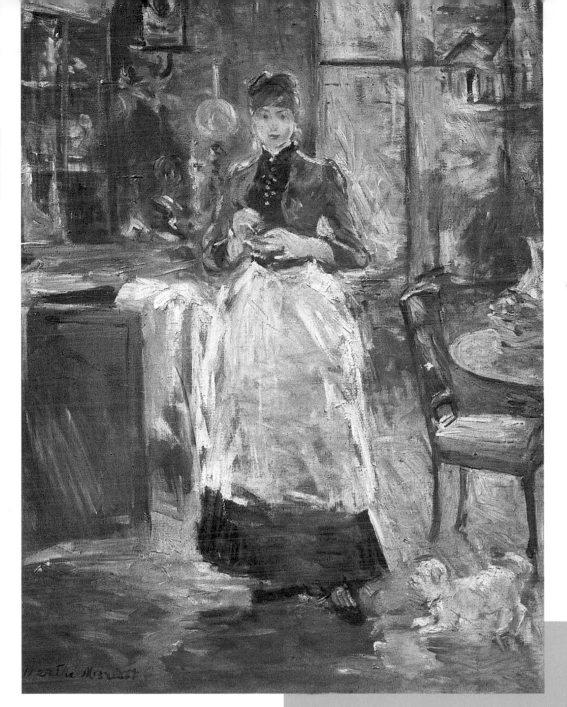

In the Dining Room

1886, oil paint
on canvas

DAILY DRAWING

Everyday life was Morisot's theme. Try sketching a series of different scenes around your home or school. Catch people as they are doing everyday things. Choose your favourite sketch to make into a painting.

This painting shows Morisot's maid in the dining room of her house. It's painted in a very sketchy way, making us feel that it was done on the spot. The maid seems to be pausing for a second, as if unexpectedly interrupted from her work to pose for a photograph. The sweeping dashes of paint give us the impression that before she stopped, this figure was rushing around the room. The little dog is also glimpsed mid-movement. Morisot uses delicate touches of white paint to create the effect of light blazing through the window and glinting on the maid's hair, shoulder, arm, hand and apron. She makes us feel the warmth and comfort of this sunny room.

EDGAR DEGAS
1834–1917

Edgar Degas didn't consider himself an Impressionist, but he often showed his paintings and sculptures in the group exhibitions. Although he studied academic art, Degas' theme was modern life and his approach revolutionary.

Degas was fascinated by ballet dancers and other performers. Unlike the Impressionists, he hated *plein-air* painting. 'The police ought to shoot anyone outside painting at an easel,' he said. Degas loved the effect of artificial light indoors.

Cafe Concert at Les Ambassadeurs

1876-7, pastel over monotype

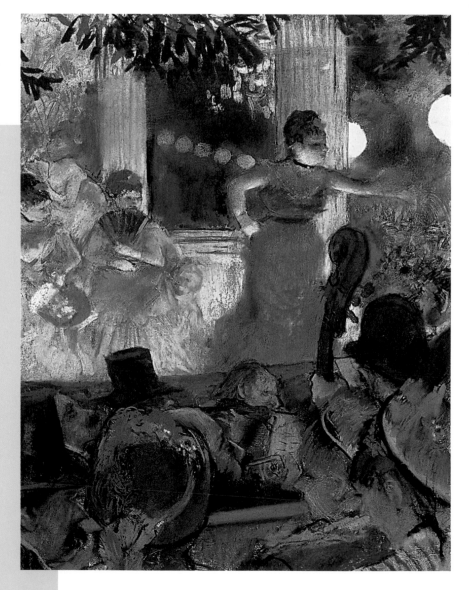

Cafe concerts were popular entertainment in Impressionist times. People came to enjoy a show while having a drink with friends. Here Degas recreates the lively atmosphere of an evening performance. The unusual viewpoint makes us feel we're sitting in the darkness of the audience, looking down at a dazzling stage. Lights from below glint on the singers' faces and costumes. The bright red, blue and yellow dresses catch our eye, drawing attention to the action on the stage. Before working with the Impressionists, Degas drew using line – he didn't think much about colour. But by working in pastel he could draw and use colour at the same time.

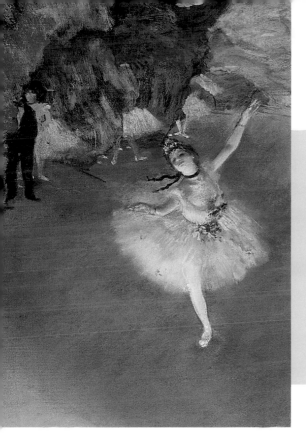

L'Etoile (The Star)

1875-76, pastel over monotype

Degas compared his art to that of a ballet dancer. Both worked very hard to produce something which looked easy. Here we see a ballet dancer curtseying gracefully to the audience. The unusual angle makes us feel we are looking at her from a box, high up above the left of the stage. From this position we also glimpse the stage manager and some dancers in the wings. Degas creates the impression of a light-footed ballerina in her delicate costume using soft pastel colours. Shimmering white touches give the effect of a spotlight shining on the stage.

Miss La La

1879, oil paint on canvas

Miss La La was a performer with the Fernando Circus, which Degas went to see daily while it was in Paris. She was famous for holding a cannon on a chain between her teeth, while hanging by her legs from a trapeze. During the show, the cannon was fired to prove that it was real and to add drama. Degas was a great admirer of the daring Miss La La. Here we see her close to the roof of the Big Top, dangling by her teeth. It's a tense moment. We can almost hear the drum roll as she prepares to spin to the ground.

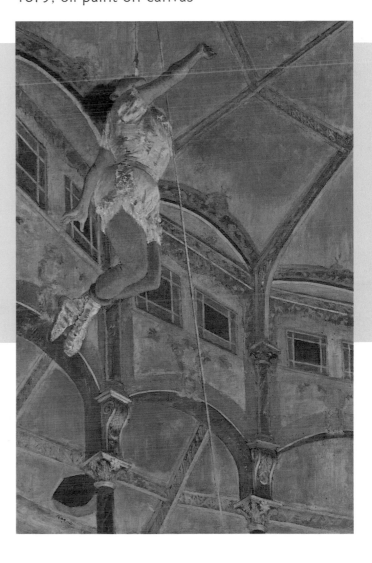

DARK TO LIGHT
Drawing in coloured pastels on dark paper is a good way of creating artificial light effects. Try making your own indoor scene by building up bright highlights in this way.

MARY CASSATT 1844–1926

'The American Impressionist.'

Mary Cassatt was daughter of an American banker. She studied in Philadelphia, then in Paris, and later in Italy and Spain. Cassatt was a close friend of painter Edgar Degas, and through him she met the other Impressionists.

Cassatt often posed for Degas, just as Morisot did for Manet. She was wealthy enough to buy many Impressionist works, as well as creating her own. Cassatt painted the everyday life and people she knew – at home, at the theatre and at the opera.

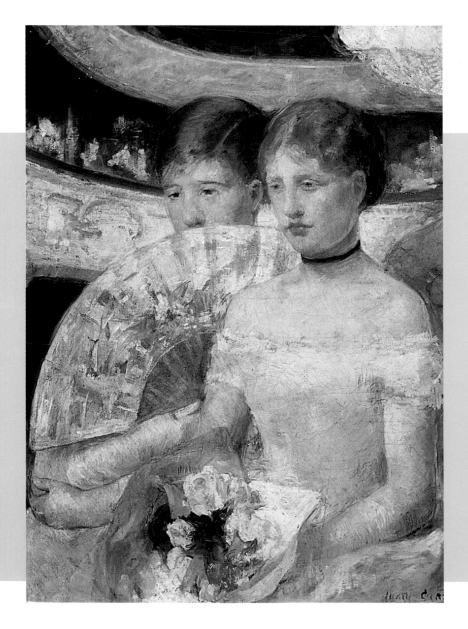

In the Loge

1882, oil paint on canvas

Here we see two girls seated in a box at the theatre. Behind them is a mirror which reflects the wider scene. The painting reminds us of Renoir's *La Loge*, but unlike the figures in this earlier work, Cassatt's girls look self conscious. One of them raises her fan to her face, as if she is hiding from view. The curve of the fan makes part of a circle that continues through the slope of other girl's shoulder and the posy of flowers in her lap. This composition brings the two figures together. Cassatt uses soft colours and broad brushstrokes to increase the intimate feeling. The atmosphere is cosy and warm.

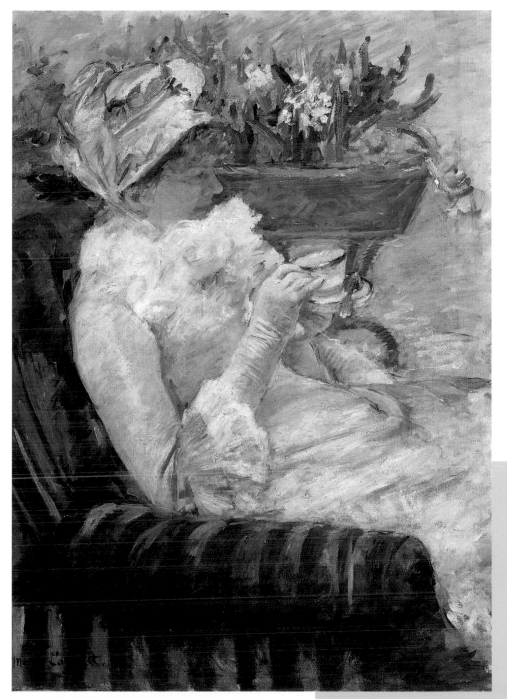

The Cup of Tea

1879, oil paint on canvas

This is a portrait of the artist's sister, Lydia. We see her in close-up, as if from a nearby chair. Mary often painted members of her family, and Lydia in particular. Here she sits holding a cup of tea. Taking tea was part of the everyday social routine for ladies in Cassatt's circle. It was an excuse to meet and entertain friends in the privacy of their homes. Lydia's gloves and bonnet suggest that she's not in her own home, but out on a visit. The soft folds and varied textures of her outfit are captured by broad, carefully placed brushstrokes. Lydia smiles as if she's enjoying the company of someone we can't see. The painting has a rosy glow which makes us feel warm, comfortable and relaxed.

AT HOME

Mary Cassatt often asked her family and friends to sit for her. Ask someone you know well to pose for a portrait. Choose a setting which makes them feel comfortable and relaxed.

GUSTAVE CAILLEBOTTE 1848–1894

'The forgotten man of Impressionism.'

Gustave Caillebotte was a marine engineer and painted as a hobby. He had plenty of money, and helped the other Impressionists by buying their work. Many of the paintings now in the Musée d'Orsay, Paris, were owned by him.

Caillebotte didn't use the rough, broken brush-work typical of Impressionism. He thought out his pictures in stages, rather than painting them on the spot. But like the other Impressionists, he was interested in scenes of everyday life.

Paris in the Rain 1877, oil paint on canvas

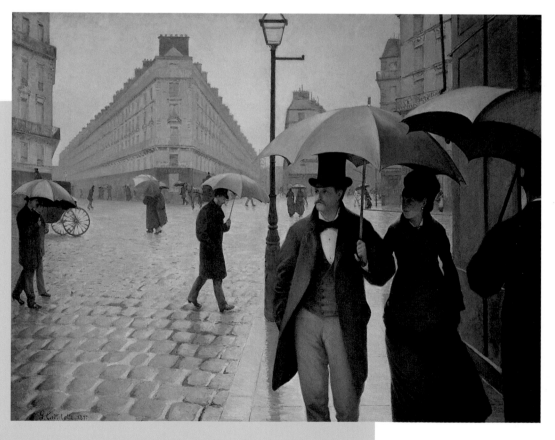

This huge painting shows an everyday scene in an area of Paris that Caillebotte knew well. As he grew up, he saw it change from a quiet hill with just a few houses on it, to a smart residential centre. Caillebotte makes us feel we're looking at a vast open space. Strong diagonal lines make the buildings zoom away into the distance, while the bold figures in the foreground seem to be walking right into us. The way that Caillebotte cuts off the man on the right reminds us of a snapshot. It's as if we are looking at the scene through a wide-angle camera lens. The Impressionists often used effects they had learnt from photography in their paintings.

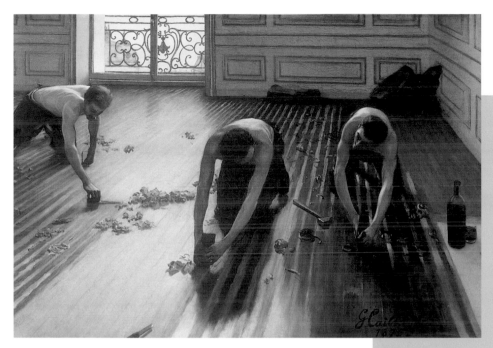

Floorplaners

1875, oil paint on canvas

Here we see an empty Parisian interior with three men planing a varnished wooden floor. This is the kind of everyday subject that the Impressionists liked to paint. Caillebotte's interest in light effects is also typical of Impressionism. Here he looks at the way the sunshine pours in through the window and hits the surface of the floor. Close to the window, the boards shine brightly, but towards the front of the painting the room and figures become very dark. Forms are lit by a just few simple highlights. This is the effect that a camera produces when you take a photograph looking towards the sun.

CAMERA COPY

Caillebotte's paintings often look as if they have been copied from photos. Try taking a picture of a city scene near you and then making it into a painting. Notice the way the camera cuts things off at the edges.

Le Pont de l'Europe

1876, oil paint on canvas

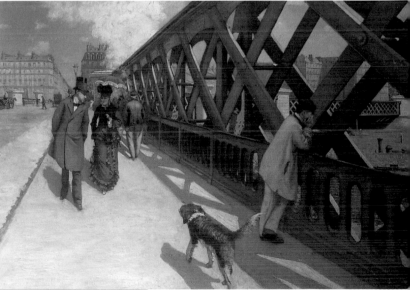

This is the great iron bridge which spanned the station of Saint-Lazare that Monet often painted. Caillebotte shows us the white puff of smoke from a train, rising up into a clear sky. He uses subtle contrasts of yellows and blues to create the impression of light and shade on a sunny day. This is an image of the modern city, with ordinary people passing by. The artist was about 28 years old when he painted this. The figure in the top hat is probably a self portrait. Our eye is drawn towards him by the diagonal lines of the bridge, making him the centre of attention.

VINCENT VAN GOGH 1853–1890

'Seeking life in colour.'

Van Gogh was born in Holland. He came to Paris to see the modern French paintings he had heard about from his brother, Theo, who bought and sold art for a living. Theo introduced Vincent to many painters, including Pissarro whose colourful brushwork inspired him.

Although Van Gogh was working at the same time as Monet and his friends, he later became known as a Post-Impressionist. He used typical Impressionist brushstrokes and everyday themes, but was more interested in colour and the way he could use it to express different emotions.

Moulin de Blute-Fin, Montmartre

1886, oil paint on canvas

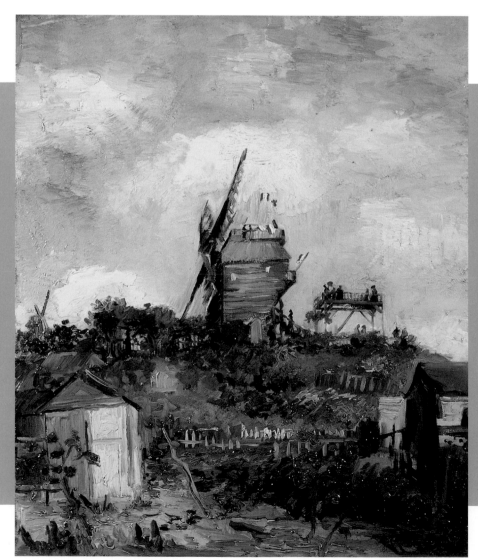

Here we see an old wooden mill, standing on an unspoilt hilltop in 1880s Paris. The sketchy painting suggests that it's a blustery day. Dashes of red, white and blue paint on top of the mill depict a set of French flags, fluttering in the breeze. Van Gogh has blurred the edges of the mill's sails to give the impression that they are spinning around. Nearby is a raised wooden platform on which we can make out a group of people, all painted with simple strokes of the brush. The effect is lively, spontaneous and fresh.

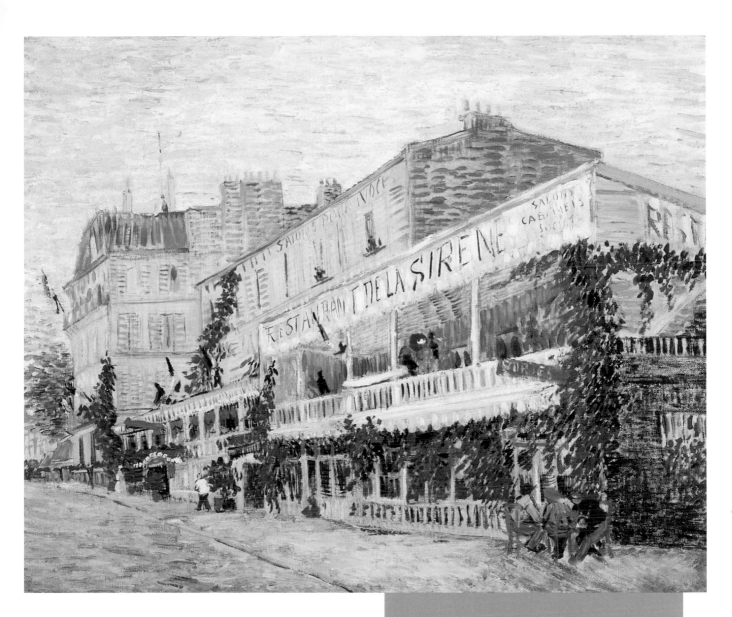

Restaurant de la Sirene, Asnières

1887, oil paint on canvas

A FEELING OF COLOUR

Van Gogh believed that colour made you feel emotion. Yellow was his favourite – it made him happy. Try painting something yellow, such as a bunch of sunflowers. When your picture is dry, cut it out and place it against a blue background, then a red one, then green and finally yellow. See the changing mood this brings about.

Van Gogh was very interested in the experiments which the Impressionists were making with colour. Here he has completely abandoned dull browns and greys and used strokes of pure colour instead. Like Monet and many other Impressionists, he has contrasted pale blue shadows with bright yellow light. The sky is dazzling in white and yellow, with little touches of blue on the left. The street is painted in the same way, using yellow paint with dabs of blue to suggest faint shadows dappling the ground. We almost feel the hot sunshine beating down on this cheery restaurant.

Many other painters were influenced by the Impressionists' use of bright colour and broken brushwork. These are just a few examples of works that were inspired by this first modern art style.

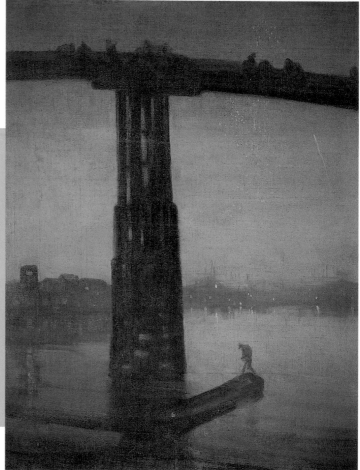

JAMES MACNEILL WHISTLER
Nocturne in Blue and Gold:
Old Battersea Bridge

1865, oil paint on canvas

This American artist worked in Paris, where he knew the Impressionists. He made this painting when he moved to England. It shows a bridge over the River Thames, with fireworks being set off in the background. The soft, blurred effect gives the impression of dim evening light.

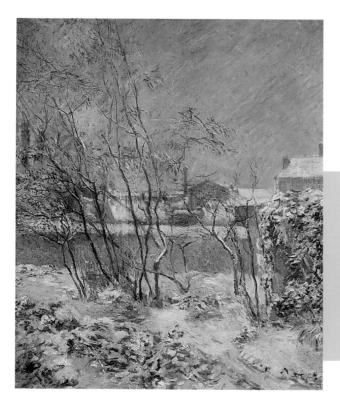

PAUL GAUGUIN
Rue Carcel Covered in Snow
1883, oil paint on canvas

Like Van Gogh, Gauguin looked at the paintings of the Impressionists and worked in the same style. His friend Pissarro told him to abandon blacks, and use only mixtures of the three primary colours. This painting makes us feel the cold of a snowy morning. The delicate brushwork makes it look very like a scene which Pissarro himself might have painted.

PAUL CÉZANNE

Tall Trees at the Jas de Bouffan

1883, oil on canvas

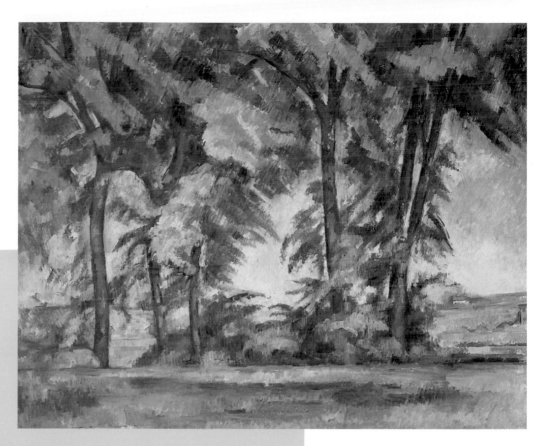

Like Gauguin, Cézanne was introduced to *plein -air* painting and the bright Impressionist palette by Pissarro. This painting shows how he separated colour into blocks, playing with complementaries to create areas of light and shade. Cézanne's brush-marks are more regular than the sketchy Impressionist strokes, yet he still creates the fleeting effect of wind-blown leaves. The bright blue between the trees makes us feel the intense heat of a summer sky.

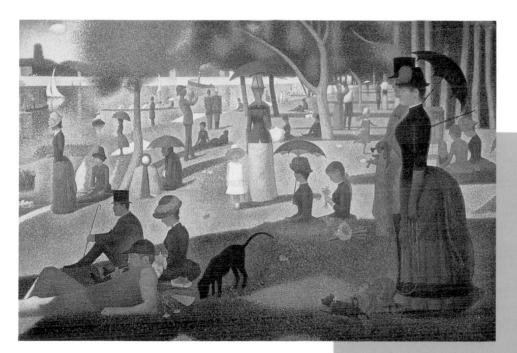

GEORGES PIERRE SEURAT

Sunday Afternoon on the Island of La Grande Jatte

1884-6, oil paint on canvas

Seurat was very interested in the science of colour and how we see it. This painting is made up of millions of dots of pure colour, placed very closely together so that our eye partially mixes them as we look. When art critic Félix Fénéon saw this work in the Impressionist show of 1886, he called the new style Neo-Impressionism.

academic art Art that followed the principles of the French Academy. The Academy promoted art that was based on traditional classical ideals.

boulevards Wide avenues in a city.

broken brushwork Paint applied in irregular patches so that the individual strokes are visible.

canvas A strong fabric which artists paint on. It is usually stretched across a wooden frame and prepared with a base coat first.

classical Relating to Ancient Greece or Rome. Classical art was based on balance, harmony and perfection of form. The subject-matter was often taken from mythology.

complementary colours Colours that are opposite each other on the colour wheel, such as red/green, blue/orange and yellow/purple.

composition The way a work of art is arranged.

Franco-Prussian War The war that raged between France and Prussia (now part of Germany) from 1870 to 1871. During this time Monet and Pissarro escaped to London.

image A picture or idea.

impasto The lumpy effect that is created when paint is applied very thickly.

juxtapose To place side by side.

loge A box in the theatre where wealthy members of the audience would sit.

metropolis A busy modern city, such as Paris.

monotype A print made by laying paper over a piece of glass or metal which has an image painted on to it in ink.

movement A style or period of art.

muted Softened or dimmed.

Neo-Impressionism A term invented by art critic Félix Fénéon to describe Seurat's style of painting in little dots of pure colour. This method is also known as Pointillism or Divisionism.

oil paint A thick paint with a buttery texture, traditionally used by many artists.

pastels Coloured chalky crayons.

pigment The powdery ingredient that gives paint its colour. Early pigments were made from natural materials; modern ones may be chemically-based.

plein-air painting Painting out in the open air.

Post-Impressionism A term used to describe art that followed some Impressionist principles and rejected others. Cézanne, Gauguin, Van Gogh and Seurat are often known as Post-Impressionists.

primary colours Red, yellow and blue. These colours can be used to mix every other colour, except shades of black and white.

pure colour Colour that is applied without mixing or blending.

self portrait An image that an artist makes of him/herself.

studio An artist's indoor workplace.

IMPRESSIONIST TIMES

1830 First passenger steam train.

1839 First photograph produced from negative by Englishman William Fox Talbot. Frenchman Eugène Chevreul publishes first book on complementary colour theory.

1840 Invention of oil paint in tubes.

1851 Emperor Napoleon III comes to power and sets out to make Paris a modern metropolis.

1870 Franco-Prussian War breaks out.

1874 First Impressionist exhibition.

1876 Second Impressionist exhibition.

1877 Third Impressionist exhibition.

1879 Fourth Impressionist exhibition. First electric light bulb made in America by Thomas Alva Edison.

1880 Fifth Impressionist exhibition. Monet separates from group.

1881 Sixth Impressionist exhibition.

1882 Seventh Impressionist exhibition.

1886 Eighth Impressionist exhibition. Later in year, critic Félix Fénéon declares Impressionism dead.

FURTHER INFORMATION

Galleries to visit

The best places to see original Impressionist works are in Paris, the city where the movement was born. The **Musée d'Orsay** has the largest collection, much of which was given to the French nation by Gustave Caillebotte. Other examples are housed in the **Orangerie** in the Tuileries Gardens. More of Monet's paintings can be seen at The **Musée Marmottan**. His garden at at Giverny can also be visited during the summer.

In the UK, the **National Gallery**, London, has a fine collection of Impressionist works, as do the nearby **Courtauld Institute Galleries**. There are also examples in the **Tate Gallery of Modern Art**, London, the **Glasgow Art Gallery Burrell Collection** and the **National Gallery of Scotland**, Edinburgh, the **National Museum of Wales**, Cardiff and the **Fitzwilliam Museum**, Cambridge.

Websites to browse

http://www.artchive.com
http://www.oir.ue.ucf.edu/wm
http://www.cafeguerbois

Books to read

Cézanne, Monet and *Van Gogh*, from the *Famous Artists* series, Watts, 1993-95

Degas and the Little Dancer by Laurence Anholt, Frances Lincoln, 1996

Impressionism by Jude Welton, Dorling Kindersley *Eyewitness Guides*, 1993

Impressionism by Judy Martin, Wayland, 1995

The Impressionists by Francesco Salvi, Macdonald Young Books *Masters of Art* series, 1994 (also a title on *Van Gogh*)

Visiting Van Gogh by Caroline Breunesse, Prestel *Adventures in Art* series, 1997 (also a title on *Monet*)

What Makes a Degas a Degas? by Richard Mühlberger, Metropolitan Museum of Art/ Cherrytree Books, 1993-95 (also titles on *Cassatt, Monet* and *Van Gogh*)

INDEX